HAND-LETTERING FOR EVERYONE

A CREATIVE WORKBOOK

CRISTINA VANKO

LOM ART

First published in Great Britain in 2016 by LOM ART, an imprint of
Michael O'Mara Books Limited
9 Lion Yard
Tremadoc Road
London SW4 7NQ

First published in the US by Perigree, an imprint of
Penguin Random House LLC

A CIP catalogue record for this book is available from the British Library.

Papers used by Michael O'Mara Books Limited are natural, recyclable products
made from wood grown in sustainable forests. The manufacturing processes
conform to the environmental regulations of the country of origin.

ISBN: 978-1-910552-50-6 in paperback print format

1 2 3 4 5 6 7 8 9 10

Printed and bound in China

www.mombooks.com

To my sister, Maria,
who told me not
to go to law school.

x x x

Contents

Draw a hand-lettered portrait of yourself.

HAND-Lettering IS

Hand-lettering is the art of drawing customized letterforms by hand. Instead of using an existing typeface that a type designer previously created, hand-lettering utilizes the hand (partnered with the creativity from your brain!) to illustrate type. This means that your unique lettering fingerprint is represented as you draw from letter to letter!

DIFFERENT FROM COMMONLY MISUSED TERMS

There a few more terms that we should clear up before diving in so that you'll be in the know.

Typography

Typography is the art of type arrangement. Typography is typeset. When typesetting, a premade typeface is selected and the type is arranged to create a composition. Also, typesetting can be digital (using a computer) or tangible (as in letterpress printing).

Handwriting

Handwriting is the writing that flourishes from your hand, whether it is in print or cursive. I like to think of handwriting as your stripped-down, naked personality written out in print. It's that magical moment when your hand hits paper without overthinking how you want it to look.

Calligraphy

Calligraphy is artful writing. Like handwriting, it is something that is executed in the moment but with more thought and skill put forth into creating the letterforms. Calligraphy is usually created with special writing utensils, like calligraphy nibs and brushes.

FOR EVERYONE

Yes, it's true. If you have a hand and something to write with, you're already halfway to becoming a hand-lettering master!

1) Are you excited? (Skip to #3)

2) Are you doubtful right now? Everyone doubts their creativity every once in a while, but remember this: you are creative. The truth is that some people choose to exercise their creativity more than others. The ability is in you, and we're going to find it!

3) Ready to jump into the world of hand-lettering? Sign this creative contract:

I, _____, AM READY!

I PROMISE TO STAY POSITIVE ABOUT MY LETTERING ABILITIES AS I MAKE MY WAY THROUGH THIS BOOK. I WILL NOT GIVE UP! I AM READY TO EMBARK ON THIS HAND-LETTERING ADVENTURE!

LET'S GO!

These next few pages are going to feel a little school-y, but it'll help in the best way possible. I promise. They're filled with neat information and fun exercises that'll teach you a bit about type's history and fundamentals.

- It'll expose you to the evolution of type design.
- How can you move forward without knowing where you came from?
- Knowing the fundamentals will bring your lettering game up to a new level.
- It'll bring inspiration for future lettering ideas.

I hope you're excited to learn all about hand-lettering, because I'm excited to see how we progress through this book together! Here's a little information about how I set up this book.

THIS BOOK IS BASED UPON DOING

I DO

On each page, I will give you some information, hand-lettered examples and tips to teach you something new about hand-lettering.

WE DO

Each page also contains exercises. My examples will provide visual references and exposure to many styles of hand-lettering that will help guide your way through the exercises. These visual examples will help you make new connections as you explore your own path.

Starting out, don't be afraid to be a copycat. A wise designer once told me, 'Copy as much as you need to, because in the end, you're not going to imitate completely.' As you copy, you'll learn to develop your own style.

YOU DO

When you complete this book, I hope you'll feel comfortable and inspired to do all the hand-lettering you want on your own!

Would you like an Adventure now? or should We have our tea first?

HISTORY & FUNDAMENTALS

THE VERY BEGINNING

Even top ballerinas have to stretch before gracing audiences with their beautiful performances. Although it might seem silly, stretching is one of those things you should do to perform well. So we will begin with a bit of stretching too.

Western typography didn't start until the middle of the 15th century. But before then, people had a means of visual communication, and boy, they got creative! Without a formal written language, the Cro-Magnons left their mark behind through cave paintings.

Use this page as your cave wall. Illustrate your process of getting food for, and eating, your last dinner. (Did you hunt and gather your meal like a caveman?)

LETTER LIKE AN EGYPTIAN

Later, ancient civilizations inched their way closer to the alphabet by developing logographic writing systems. In these systems, symbols represented words, concepts and ideas. Examples of this form of writing can be found in Chinese characters, cuneiform and hieroglyphs.

Today, it's funny how some of our conversations head in a visual direction with the rise in popularity of emoticons and emojis. So let's modernize, but still talk like an Egyptian! Symbolically, tell me about your day.

I know what you're thinking—what does this have to do with lettering? Well, everything. You have the power to bring type to life through illustrating your letterforms. Plus, for me, thinking of imagery helps translate my lettering decisions onto paper, so I wanted to warm up your thinking skills.

The Egyptians didn't just create hieroglyphs. They also developed the first consonant alphabet, known as the abjad. Now, each symbol represented a particular sound. Later, the Phoenicians jumped on the bandwagon, and then the Greeks refined it even further and created the first true alphabet that included vowels and paved the way to what the Western world embraces today—the Roman alphabet.

I've always wondered how something so abstract turned into a letter for the alphabet. Now it's your turn. Create your own letter to be added to the alphabet.

Fun fact: The first Roman alphabet consisted of only capital letters.

onkeying Around

During the Medieval Ages, scribing monks hand-penned books with blackletter alphabets. Blackletter is a compact, heavy typeface formed with a chiselled calligraphy pen. Aside from the calligraphic lettering, the monks decorated pages with ornamental drop caps and border designs. The decorations lit up the page so much that these books are now known as illuminated manuscripts.

Blackletter is made up of rhythmic strokes of thick and thin lines. Practise the common calligraphy strokes here, in order to use them as a base to form your letters later. Don't have a calligraphy pen? Use whatever you've got—or create your own 'nib' by taping two pencils together to draw thick lines consistently.

Aa Bb Cc Dd Ee Ff Gg

Hh Ii Jj Kk Ll Mm Nn

Oo Pp Qq Rr Ss Tt

Uu Vv Ww Xx Yy Zz

A drop cap is a large initial letter that drops below the first line of a paragraph. In illuminated manuscripts, drop caps had swashes, swirls, iconic symbols and detail all interweaved to decorate the letter and the space it occupied.

Illuminate this page and scribe your story. Pull your reader in by using a drop cap and border decorations. Put your strokes together to form calligraphy for the body text on the page. Need an idea for a story? Write about the first time you enjoyed your favourite dessert.

When you're finished, tear out this page and roll it up like a scroll!

You know how your hand gets tired after writing too much? The scribes' sleepy hands got their remedy with the invention of movable type thanks to Johannes Gutenberg. Movable type is exactly what it sounds like—type cast into blocks that could be physically moved. Putting individual letters of type together composed words. The first set of type was set in blackletter and cast in metal.

Today, newspapers aren't set in blackletter due to how type has evolved, but it is common to see newspaper mastheads or nameplates in blackletter. Create some breaking news headlines here.

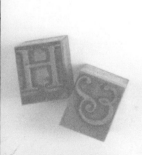
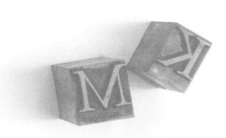

Fill in the boxes with letters of your choice. Cut the boxes out.
Play around with the arrangement and paste them on the next page.

Fun fact: The common phrases 'out of sorts' and 'mind your p's and q's' originated from letterpress printing culture when the cases of type got messy.

Notice how you're restricted to the box when it comes to placing your type? Printers have to be mindful of spacing so the type doesn't cause legibility issues or create any awkwardness.

Play with spacing between letters (kerning) and between lines of type (leading). When you're done, lock up your type (paste it) onto this 'press bed'.

WIDE

FRESH AIR
MAKES FOR
EASY BREATHING.

TOO RANDOM

TIGHT

HELP ME!
I CANNOT
BREATHE!

TOO CLOSE

Fun fact: In order to get an impression from the letterpress, blocks of type need to be 2.33 centimetres tall.

THE BIRTH OF THE SERIF

While blackletter type seemed squashed together, the next wave of typefaces saved the day by offering some breathing room and the introduction of the serif, or the little feet that hang off the letter.

Humanist typefaces originate from calligraphy, yet have little variation between the thicknesses of the strokes. Some notable characteristics of Humanist faces are the sloping crossbars on the 'e' and the low x-height.

CALLIGRAPHIC INFLUENCE SLOPING CROSSBAR LOW X-HEIGHT

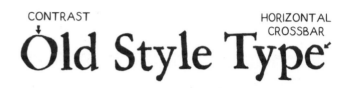

Old Style typefaces were created to more closely mimic handwriting, with less calligraphic influence. Letters started standing more upright; there were horizontal crossbars and a bit more contrast with line strokes.

CONTRAST HORIZONTAL CROSSBAR

Old Style Type

The x-height is the height for the main lower-case letters in a typeface. X-height is a great characteristic to look at when combining type. Type with similar characteristics flow better.

Write the word 'typography' below in your handwriting. When you've finished writing, add some thin serifs. Afterwards, add some variation in line weight for the strokes. Remember, it's important to stay consistent with the weight throughout the word. Lastly, form your serifs more like a wedge.

Wasn't that magical? You just made your type evolve from Humanist to Old Style!

ROMAN

Today's definition of 'Roman' type has evolved to mean the regular, upright position of a typeface. Yesterday's Roman characteristics included sharp, straight lines, supple curves, thick and thin strokes, angled stressing and incised serifs. This type of Roman is truly monumental, as stonecutters used it to carve letters onto monuments and sculpture pieces.

Find type carved onto a piece of stone. Place this page on top and rub a crayon on top of the stones to reveal a rubbing of the type.

Fun fact: Most artisans carved capitals within a square, which bred the term 'square capitals'.

A NEW SLANT

Feeling the need for change, more space for letters on a page and to make his books more appealing, a Venetian printer named Aldus Manutius created italics. Characterized by slanted, rhythmic downstrokes and curved-up serifs, italics actually set the stage for cursive handwriting.

Using italics, letter this Frank Sinatra quote: 'Angles are attitudes'.

Note: In typeset layouts, italic type is one of the many ways to show emphasis. In hand-lettering, there are a myriad of ways to highlight type, as we'll see.

PERFECTION

During the Enlightenment period, many intellectuals in the arts, humanities and sciences broke away from tradition. The period called for innovation, and the typographer John Baskerville rebelled by setting out to create the perfect typeface. He did just that by creating Baskerville, the typeface that marked the transitional period of type.

Use the grid to create the perfect letter. Cut out circles in order to construct your curves and serifs (as seen above).

Fun fact: The point system, which is used for measuring type, was created during this period.

EXTREME CONTRAST

HAIRLINE THIN SERIFS

STRIKE A POSE

NO BRACKETING

VERTICAL AXIS

The modern period of type shook the typographic world even further by deviating from the handwritten notions of the past. Italy's Giambattista Bodoni and France's Firmin Didot are both credited for these drastic changes by taking their type in a more expressive, symmetric direction by applying heavier contrast paired with hairline serifs. And the expression didn't stop there...

Bodoni and Didot are so elegant that they frequent the covers of fashion magazines. With modern type, create your own titles for these fashion magazines.

The Industrial Revolution added more fuel to the fire in terms of expression. Type was now needed for commercial use. Large type was necessary so it could be seen by the masses. While previous type was cast in metal, which was heavy and expensive, technical advancements and the creation of wood type swept in to save the day. Wood type introduced chunky typefaces called slab serifs and quirky display faces. This combination became the trademark of the period.

What's the one thing you want most right now? World peace? Happiness? Pizza? Create a wanted poster using slab serifs.

BOLDER TYPE

The popularity of slab serif type was relatively short-lived, so now advertisers needed a new way to attract viewers. Display, or decorative, typefaces were born out of the need to be eye-catching. If the previous technical improvements were the timeless, classical masterpieces that appeal forever, display type is bubble-gum pop, trendy and short-lived, but fun while they last.

Pick a pop song. Letter the lyrics, using a different display face for each word.

Do these lyrics look like they have too much going on? Glad you agree. Save display type for special instances. Think of it like the cherry on top of a sundae, a nice treat.

OUTLINES DECORATIVE
INLINES SHADOWS

What pop singer or band is your biggest guilty pleasure? Create a poster for them, using slab serifs and display faces.

Does this combination of type look familiar? Old wood type concert posters commonly used this combination to advertise events.

simmer down now

If every day were Halloween, we'd get sick of sweets pretty quickly. Similarly, typographers were getting sick of the over-embellished typographic treats of display faces. Consequently, sans serif typefaces were created in order to exemplify the beauty of the basic letterform. Sans serifs have no serifs, little to no stroke variation, and large x-heights.

There are a few different types of sans serifs. Can you spot all the differences? Circle them.

Aa Bb Cc Dd Ee
Ff Gg Hh Ii Jj Kk Ll
Mm Nn Oo Pp Qq
Rr Ss Tt Uu Vv Ww
Xx Yy Zz

Aa Bb Cc Dd Ee
Ff Gg Hh Ii Jj Kk Ll
Mm Nn Oo Pp Qq
Rr Ss Tt Uu Vv Ww
Xx Yy Zz

Aa Bb Cc Dd Ee
Ff Gg Hh Ii Jj Kk Ll
Mm Nn Oo Pp Qq
Rr Ss Tt Uu Vv Ww
Xx Yy Zz

Aa Bb Cc Dd Ee
Ff Gg Hh Ii Jj Kk Ll
Mm Nn Oo Pp Qq
Rr Ss Tt Uu Vv Ww
Xx Yy Zz

NARROW T AND F SQUARE DOT SQUARE S LARGE X-HEIGHT

Helvetica is everywhere.

TWO-STOREYED A

The Swiss aren't only famous for their cheese. Switzerland's Max Miedinger designed one of the most used typefaces of all time. For real. Helvetica is all around us. From navigation systems to nutrition labels to signage, it is everywhere.

Spot ten examples of Helvetica. Pretty basic, right? Hand-letter the tenth Helvetica example you find, and then give it more personality.

Fun fact: The word 'Helvetica' means Swiss in Latin.

Geometric typefaces were created based on basic shapes like circles, squares and triangles. Geometric type also rejected decoration, and it was celebrated for its clean designs. So the next time someone tells you to think outside the box, remember that cool things can also be created from the inside, like geometric type!

Pick a shape. Now create letterforms based on that shape. There's no need to create a perfect, clean typeface here. Create a silly one...

Or divide and combine shapes to create something totally new.

DON'T DOUBT *The Hand*

What goes around comes around. When typeface design veered the furthest away from the calligraphic and handwritten style, guess what became hip again? Cursive and handwritten typefaces, of course! While many styles have calligraphic influence, there are faces that have a 'swashy' look, created through brush techniques.

Take a product that doesn't have a logo and give it a logo with a handwritten or cursive look. Examples of products: your pillow, your favourite coffee mug, your boots, etc.

Think back to computers from the 1980s. They resembled boxy robots. Similarly, these early personal computers created bitmapped typefaces that used pixels, or picture units, on a grid to make up letters far less elegant and versatile than what they can create today.

Create a letter here. When you're done, colour in the boxes corresponding to all the places where the letter falls.

This is an example of a bitmap. Today, imagery on computers has improved so much that we don't see this boxiness anymore.

Use the grids below to create letters. Stick to the true pixel square shape within the boxes, or get creative by using other shapes or even lines to create your type.

Fun fact: Many bitmapped typefaces use 8px x 8px grids.

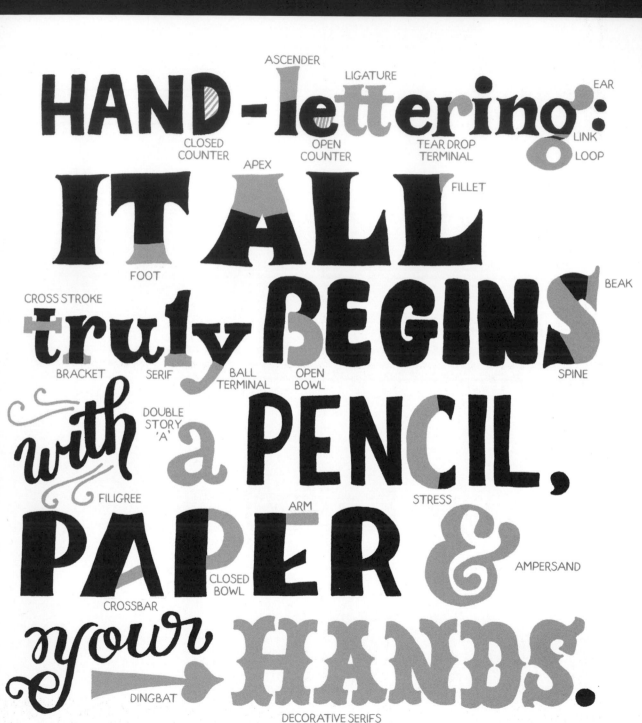

HAND-lettering: IT ALL truly BEGINS with a PENCIL, PAPER & your HANDS.

ASCENDER · LIGATURE · EAR · CLOSED COUNTER · OPEN COUNTER · TEAR DROP TERMINAL · LINK · LOOP · APEX · FILLET · FOOT · CROSS STROKE · BEAK · BRACKET · SERIF · BALL TERMINAL · OPEN BOWL · SPINE · DOUBLE STORY 'A' · FILIGREE · ARM · STRESS · CLOSED BOWL · AMPERSAND · CROSSBAR · DINGBAT · DECORATIVE SERIFS

Just like the bones in your body, letterforms have names for all the structures and details that make up their shape.

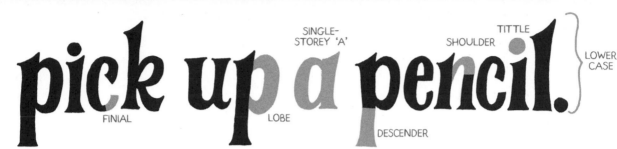

pick up a pencil.

SINGLE-STOREY 'A'
SHOULDER
TITTLE
LOWER CASE
FINIAL
LOBE
DESCENDER

Make your mark.

ASCENDER LINE
X-HEIGHT/BODY LINE
BASELINE
DESCENDER LINE
EYE
APERTURE
ARC
SENTENCE CASE
TAIL
AXIS
TERMINAL
LEG

BRILLIANT! Am I right?!

STEM
DIAGONAL STROKE
SWASH
SPUR
UPPER CASE

SO START MAKING

THIN
LIGHT
REGULAR

YOUR OWN

EXTENDED
ITALIC

AMAZING! REALLY. NOW GO !!!!! Letter away!

BOLD
CONDENSED
SCRIPT

Some of my favourite exercises are simply reviewing the anatomy of type, and seeing what I can do to differentiate my letters by taking a certain aspect and exploring all the options imaginable.

DOWNSTROKES (TAILS)

Will it curl? Will it be straight and rigid? Will it curve? Will it look like a cat's tail? Will it act as a flourish-y element to underline the word?

OPENINGS (COUNTERS, EYES)

Will it be wide open? Will there be very little space? Will it have a boxy shape? Will the axis be dramatic?

CROSSBARS
Will it loop? Will it cross at an angle? Will it extend past the stem for extra emphasis?

APEXES & VERTEXES
Will it be a straight line? Will it have some sort of adornment?

There are 206 bones in the human body. Now, there's no excuse not to memorize all of the anatomy of type, right?

LEGS
Will it extend below the baseline? Will it be curvy?

BRACKETS
Will it have a distinctive shape? Will it curve deeply? Will it taper?

SPINES
Will it be curvy? Will it be horizontal? Will it be vertical?

BEAKS
Will it be large? Will it be dramatic? How pronounced will it be?

Next time you're out with friends, throw some type anatomy into casual conversation. You will immediately be the coolest cat in the group.

A CASE FOR SPACE

While it's always OK to let your mind wander, don't be a total space cadet when it comes to spacing. Kerning is the adjustment of space between letters, while leading is the adjustment of space between lines. It's important to create equal perceived space between letters and lines of text so that your words stay legible and your overall layout stays proportional.

In the following examples, circle problem areas:

Always LOOK UP

Wish UPON A Star

stars SO BRIGHT I DON'T even NEED Light

TO THE Moon!

It's important to remember that each letter is shaped differently and all letters within a group do not necessarily need to be kerned the same way. The key to good kerning is understanding the relationships between letters and overall visual appeal. It helps to kern in groups of letters so you don't get too overwhelmed at the start. Want another way to check your spacing? Turn your piece upside down—it'll give you another perspective.

Play around with spacing. Exaggerate the kerning and leading, just for fun. Think of word meaning when creating your type.

The term 'leading' comes from letterpress printing, since they would space out lines of text with thin pieces of lead before locking up the press bed for printing.

If you want to make your type have style for miles, ligatures are where it's at. Ligatures are letters that share certain characteristics to form a joint piece of type. Ligatures are not only meant for added style. They're also used to connect two letters whose styles are different from one another. Whether your letters are very simple or highly decorated, it's that little something extra that makes your type look special.

Practise connecting pairs of adjacent letters using ligatures.

Fun fact: The ampersand symbol, &, is a ligature!

Ligatures also allow us to think of the relationships among the whole word and the entire piece. Think about type anatomy and how the anatomy of the letters could work to fill the space in an interesting way. Ligatures can offer an elegant connection and framing device for letters or words that are spaced far apart. It's important not to go too wild with ligatures so that you maintain overall balance.

Practise more ligatures by writing your funniest friend's name here. Then letter the funniest phrase he or she has ever uttered. Once the letters are in place, use ligatures to connect them in unexpected ways.

Fun fact: 'Ligature' means to tie something together.

You know when a friend has a pressing story to share, with a lot of hype leading up to it? When you finally hear the story and its not-so-exciting ending, you long for something a little bit more. This anticlimactic feeling results from type too—when it has no visual flair or clever visual type combinations whatsoever.

One way to jazz things up is to literally give your type an exciting ending by embellishing the tails with an elaborate terminal or ending curve. Letters that have strong descenders lend themselves best to this: g, p, j, q and y. Now, practise lettering a few of these 'long-tailed' words on your own.

X MARKS THE SPOT

While lettering takes you off the beaten path to explore new territory, sometimes you just want to know a route before you go your own way. There are a variety of lines you can use as your tour guides in order to create consistent type.

Use the guides below to letter the titles of the last few movies you've seen.

ASCENT LINE

CAP LINE ASCENDER HEIGHT

MEAN LINE

 X-HEIGHT

BASE LINE

DESCENT LINE DESCENDER HEIGHT

BE YOUR OWN GUIDE

Practise making guidelines here to letter
the names of movie stars you'd like to hang out with:

With a small x-height

With a large ascender line

With an angled x-height

With no more straight lines!

Keep in mind: If you have a large x-height, your type will be more visible—
with that, your ascender and descender size typically decreases as well.

ALL LETTERS
CREATED EQUAL

Let's gear you up to create a full alphabet. When building a proportional alphabet, think of it as a row of terraced houses. Overall, the basic look of each house is the same, but there are tiny differences to set them apart.

If you want to get technical with proportion, there are a few things to consider when you create letterforms. To start, pick a few letters to begin your alphabet. I choose the width of my widest letter (m/w) to create thinner widths of the other letters in the alphabet.

Then decide on the following:
- Stroke contrast
- Curve shape
- Diagonal angle
- How far arms extend
- Shape of any openings (bowls, eyes, apertures)
- Shape of crossbars
- Design elements to add

- (Add your necessary element here) _____
- (Add your necessary element here) _____
- (Add your necessary element here) _____
- (Add your necessary element here) _____
- Overall consistency check

Practise letters for your alphabet on the next couple of pages.

ABCDEFGHI
JKLMNOPQ
RSTUVWXY&Z

It's been said that writing the word 'hamburger' will give you the general look and feel for a whole alphabet. Think about a whole alphabet you'd like to hand-letter. What characteristics would it have?

When you're done thinking, cover this page with the word 'hamburger'.

Across a hand-lettering piece, your repeated letters don't have to match exactly, but they should still be similar. Although I never create whole alphabets before hand-lettering a project, creating a whole alphabet is a great creative challenge.

Create an alphabet featuring the characteristics you practised on the previous pages. Strive for consistency among the letters.

PROCESS

YOUR PROCESS

When starting to letter, it's tricky to develop a process that works for you. It's like learning how to ride a bicycle. For me, I started with training wheels and rode happily until I was ready for a new challenge. One day I mustered up the courage to try riding a two-wheeled bike. On my first attempt, I fell flat on my nose. After that, lots of practice helped me find a process that works for me. Soon enough, you'll find smooth sailing too.

What is a hobby that took you a long time to master? Letter it here.

After lettering that, what did your process look like? List the steps here.

INSPIRATION

My first step is inspiration. Most of the time, this is not an 'official' phase, meaning I don't have a project to work on (just yet). Whether I'm in a visually stimulating environment that gives me an idea or if I hear something said that I may want to letter, being out and about and living my everyday life is a good place to start. Even when I know I have a project to work on, I still like to be aware of my surroundings, but I also morph back into research mode, checking out lots of books from the library and surfing the Internet, but in general I find the most inspiration from sketching to find the ideal direction I want to pursue.

IDEA

When thinking about the words I'm going to letter, I always use the 'never settle with your first idea' rule. Your first idea isn't always your best idea, so I like to come up with a few different approaches so that I know I've explored all my options before making a choice.

SKETCH

This is just me and my pencil. The possibilities are endless! This is a great time to experiment with combinations that you wouldn't necessarily believe would work, because who knows—they just might work beautifully! This is the time to push the boundaries to see what you can create.

PLAY

Tapping into your inner child always leads to some awesome discoveries. When I play, I like to play mostly with new media. Whether it's with art supplies, blades of grass or even food, it's important to explore where your imagination will take you.

THE DRAWING BOARD

At this point, I know visually what I'd like my lettering to look like based on my sketches, and I finalize the piece by drawing it out in pencil.

EXTRA

This is when I think about adding any finesse—design or illustrative elements around my letters or in the overall piece that I didn't originally think to try.

INSPECTION

After adding in any extra elements, I finish up by taking a step back to see if my additions make sense and if the piece feels cohesive as a whole. Then I decide whether I need to go back to the drawing board or move forward.

GET INKY

Inking is the final stage and leads to a permanent piece that can live forever!

Let's take a closer look at each step of the process.

A	B	C	D	
I	J	K	L	M

Every-
WHERE
YOU
Look

Look right, look left, look up, look down. Little did you know, hand-lettering inspiration is everywhere! From the signage at the local shops in your neighbourhood, to the advertisements plastered on billboards, to the manhole cover you walk over while strutting down the street, visual inspiration is everywhere!

In the boxes, sketch found letters that inspire you to hand-letter.

R	S
X	Y
4	5

E	F	G	H	
N	O	P	Q	
T	U	V	W	
Z	0	1	2	3
6	7	8	9	

PLACES TO FIND INSPIRATION

Inspiration is essential since it sparks ideas and brings new possibilities to light. Being inspired by the world around me is what keeps me curious and motivated to learn and experiment through my hand-lettering.

INTERNAL

Memory, happiness, hope, love, pride, pleasure, euphoria, need, hunger, desire, reflections...

EXTERNAL

People, nature, music, poetry, managers, mentors, role models, heroes, animals, insects, speeches...

THE LETTERING SuperHighway

There are so many fabulous letterers all over the globe.
Luckily, the Internet gives us the opportunity to see a host
of amazing lettering and to connect with some of these
creative talents. So surf the web and drop by some of
the many fantastic hand-letterers' websites.

When you find a few favourites, write their names down here.
Revisit their work every so often to check out their latest work.

Now that you've discovered some favourites, I thought I'd share
some of mine. You'll happen to see some excellent lettering tips
throughout the book from this fabulous group!

Shauna Panczyszyn, Lila Symons, Joseph Alessio, Marlene Silveira, Allison Tylek,
Nick Stokes, Annie Trincot, Chris Ballasiotes, Rob Lewis, Fozzy Castro-Dayrit,
Jenna Blazevich, Timothy Goodman, Josh LaFayette, Frances MacLeod,
Gabriella Thompson, John Passafiume, Karen Kurycki, Will Bryant, Bob Ewing,
Janie Javier, Jill De Haan, Carolyn Sewell, Risa Rodil, Kristin Drozdowski,
Jay Roeder, Hannah Boresow, Jeff Rogers, Leo Zarosinski, Sasha Prood,
Neil Tasker and Laura Stephen.

ADJECTIVE

A word or phrase naming an attribute, added to or grammatically related to a noun to describe it.

Choose a few of your favourite adjectives and incorporate each one's meaning into your lettering.

VERB

A word used to describe an action or occurence.

Now do the same thing with a few of your favourite verbs.

come to your senses

Sometimes everything you need is literally right in front of you, so stop what you're doing and use your senses to letter this page.

smell — What do you smell right now? The sweetness of the air, cookies in the oven or fresh laundry? Use this scent as the tone for your piece.

hear — What did you just hear? Music, a conversation, silence? Use this for lettering content or the words to hand-letter.

see — See any clouds, grass or your sleeping puppy? Incorporate something you see as a symbolic or illustrative element.

touch — Touch something near you. Rough, soft, smooth? Use this feeling as an overall texture.

taste — Taste something sweet, sour, spicy or bland? Use this for extra finessing.

Using what you've sensed, letter your piece below:

DON'T BE AFRAID TO EXPERIMENT AND PLAY

Shauna Panczyszyn

No 2

try the SUBTRACTIVE Method

Lila Symons

WORD ON THE STREET

You know who has some of the best stories? The people on the street that you happen to meet when you're not paying attention to your phone and/or avoiding life in real time.

Ask people to write down their best advice here.

A Young Child

A Teenager

The Smartest Person You Know

A Person with an Interesting Outfit

A Street Performer

A Doctor

A Parent

A Grandparent

A Person with Colourful Hair

A Policeman

An Artist

A Chef

Examine how different people write to find some inspiration on the many ways
to shape a letter—and maybe their advice will even inspire you for content, too.

Sometimes when I'm short on ideas, I like to think of my favourite things in order to help me decide what I want to hand-letter.

Fill in the blanks with favourites.

What is your favourite...?

Place _____

Food _____

Word _____

Quote _____

Sport _____

Celebrity _____

Artist _____

Memory _____

Movie _____

Animal _____

Holiday _____

Vacation Spot _____

Season _____

Story _____

Cartoon Character _____

Vegetable _____

Dessert _____

School Subject _____

Day of the Week _____

Song _____

Book _____

Learn STEAL FROM FROM Every NO ONE One

Joseph Alessio

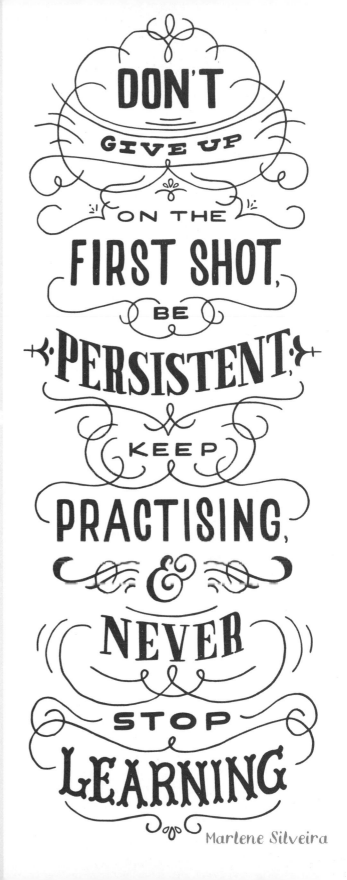

DON'T GIVE UP ON THE FIRST SHOT, BE PERSISTENT, KEEP PRACTISING, & NEVER STOP LEARNING

Marlene Silveira

ok i'm still
STUCK 2

your best quality; DREAM.
your date of birth;
maturita level
FOOD; guests; THE most your HAPPY
TIME; EXCITING place;
ALL ITERATION; story you know; LIFE QUOTE
memory; EMOTION; hobby
breaking news; GOAL pet;
SEASON
FUNNIEST THING any - mirror;
YOU HEARD YOUR
child's name;
FRIEND SAY;
current event; SOMETHING
ally SAYINGS TO CHANGE
YOUR PARENTS SAY; THE WORLD
LYRICS
your fav'rite definition
word of random word;
destination;

SKETCHPLORATION

Bookmark this page, close your eyes. Turn your book upside down and side to side a few times, and use a mirror to pick something from the previous page. Now sketch the many ways you could letter this word or phrase. Do not even think about starting your final piece yet. This is all about sketchploration.

The possibilities are endless. I begin sketching for a while to see what organically happens and to play around a bit. After some time, I like to take more important aspects of the piece into consideration (that's probably why I spend the most amount of time on this part of the process).

Often we sketch so much that we have piles and piles of drawings that we don't know what to do with. Now you do! With all your sketches, create a graveyard of killed work. Killed work is the exploratory work that you didn't fall in love with initially. I like to keep my sketches in a pile, which I call my lettering graveyard. I revisit old pieces to see where my thoughts were, to see how my lettering has progressed, to see what skills I could improve, and lastly to see if I can revive any ideas when I'm up for a future challenge.

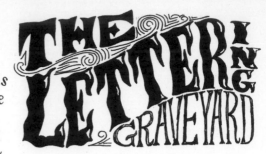

Paste some pieces of your sketches here:

IDEAS TO REVISIT

Hand-letter the titles of pieces or ideas you want to revisit on the gravestones.

GRAMMAR AIN'T A THING

This may be the one time in your life that you're going to hear this, but when it comes to hand-lettering, good grammar is not important. That means no more strict capitalization or punctuation rules! But, why is that?

Rather than focusing on grammar, hand-lettering places greater importance on how the message looks as a whole by using a ranking system of organization called hierarchy. When structuring a piece of hand-lettering, divide your message into groups based on importance.

When finished, remember to proofread your work for accuracy.

Using the key, note your levels of hierarchy within the following quotes here.

KEY:
(1 being the most important)
1. Circle
2. Underline
3. Star ✳
4. Triangle ▲
5. X ✕

You can have as many levels of hierarchy as you want.

WE'RE ALL MAD HERE.

YOU'RE ENTIRELY BONKERS. BUT I'LL TELL YOU A SECRET, ALL THE BEST PEOPLE ARE.

IF I HAD A WORLD OF MY OWN, EVERYTHING WOULD BE NONSENSE.

IT'S ALWAYS TEATIME.

IMAGINATION IS THE ONLY WEAPON IN THE WAR AGAINST REALITY.

AT ANY RATE, THERE'S NO HARM IN TRYING.

of hierarchy by taking different stylistic choices into consideration, such as type style, size, weight, spacing and layout.

Apply different stylistic choices to each group of emphasis. See how it all works together.

Letter the same quote again. Pick another way to differentiate your hierarchy. Provide different stylistic choices for each of those groups one more time.

Differentiation provides some visual interest in your piece. If you change too many things up, it may be too much. On the whole, it's important to make sure the piece feels balanced.

IF I HAD
A WORLD
of my own
EVERYTHING
WOULD BE
NONSENSE

IF I HAD
A WORLD ←2⅓
of my own
EVERYTHING
WOULD BE
NONSENSE

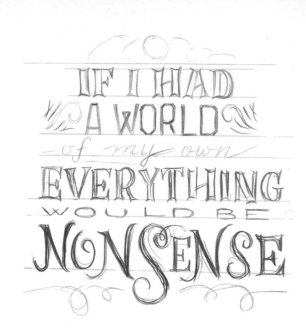

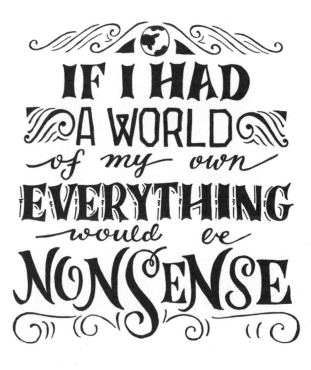

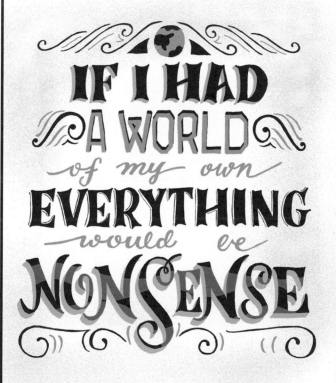

WHAT A CATCH

When choosing words to emphasize, hierarchy in the word's meaning should always be considered first. Although hierarchy assumes some groups of type may be more important than others, sometimes even the least important words can join in on the fun by applying a little extra design to the catchwords within a phrase.

Hand-letter some catchwords here.

TRADITIONAL GRID

A good way to break up type is to map out a geometrical grid. Using a grid makes it easier to predict placement and know which boundaries your type has to keep within for the overall piece. Think of the grid as a skeleton, and dress it up with your own lettering.

Pick four quotes and letter them in the grids below.

Did you decide to use cohesive elements to make this a series?

Below, re-create the same four quotes with your own grid.

Ah, freedom! Did you find it easier when you're not restricted to a premade grid?

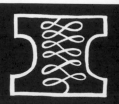

Take a break and fill out the boxes with letters of differing heights and widths.

BREAK THE traditional GRID

Sometimes we focus on stylizing type so much that we forget that we can break away from the traditional grid's layout by using different shapes and baselines.

Fill in the grids below with quotes of your choice.

LEARN the RULES THEN YOU CAN BREAK THEM

FRAME THIS

While grids are a great way to size your type within a piece, you can also change your overall type's outside shape by playing with frames.

Using the frames below, hand-letter your favourite memories.

TAKE-a-BREAK

When life gets too busy, we take a break. When type gets too busy, we break up the text. In addition to stylistically dividing up the text by lettering style, you can also use dividers. Dividers break up the whole into parts and can provide a much-needed break for the eye when things get a little chaotic.

Choose a long quote and use dividers when necessary. Need help choosing a quote? Use an excerpt from an interesting speech.

Dividers : OR : or
could be : ANGULAR : CURVY
 : OR : or even
VERTICAL : horizontal : ORGANIC

GOODY GOLLY
DIVIDERS RULE

Dividers COULD emphasize IMPORTANT TEXT

GIVE your EYES
a much-needed BREAK
with DIVIDERS

SPACE OFFERS us SOME ROOM BREATHE

HAND Lettering NEEDS Space TOO!

You know how you talk differently when you're around different people? A softer, higher pitch around babies, professionally around your boss and high-pitched around cute animals? Similarly, your lettering can differ depending on your audience.

Letter 'Hi, my name is _____' according to each specific audience.

TO: A Group of Children

TO: Your Boss

TO: Your Best Friend

TO: Your Significant Other

TO: A Dog

TO: An Athlete

TO: An Artist

TO: A Scientist

TO: An Astronaut

MATTER of FACT

Does the word or phrase you're lettering relate to a particular time period? Would an illustrative element help get the point across? These are important questions to consider when deciding what aesthetic qualities will best suit your subject matter.

For example, when I think of summer, the sun, beaches and ice-cream cones come to mind. When I think of school, I think of books, backpacks and pencils. When I think of art, paintbrushes, canvases and berets come to mind.

Let's play with your favourite holiday. Letter that holiday's name or a holiday-appropriate phrase. Illustrate the letters in every thematic way you can think of.

Kinda looks like the house in the neighbourhood where the neighbour went overboard with their decorations, right?

Now take your three favourite elements and incorporate them into your lettering.

Lastly, filter it down to one element that gives just a hint of the holiday.

More REALLY AIN'T Merrier,
RIGHT?

The lettering CATWALK

When I have an important event to go to, I like to go through my closet and grab a few items of clothing that are appropriate for the event and that I'd be excited about wearing in order to try on many different outfit choices. This often ends with a messy closet and a fashion show for my friends, but in the end, I like knowing I went with my best ensemble. Similarly, with a lettering piece, the options to dress up your lettering are endless. I like to explore and sketch up the many different avenues before settling on a style of lettering for my piece.

GET READY for a FASHION SHOW!

Blackletter

ANTIQUE Sans Serif

representational

SERIF FREESTYLE

script lettering ORNATE

Before we sort through the many styles, dress up some letters in clothing here.

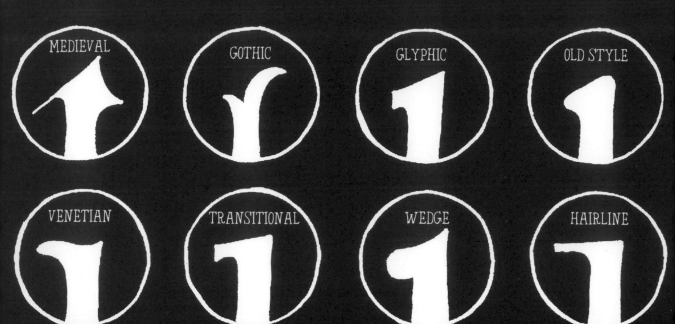

MEDIEVAL · GOTHIC · GLYPHIC · OLD STYLE

VENETIAN · TRANSITIONAL · WEDGE · HAIRLINE

SERIF

Some call them feet...The tapered corner that projects off at the end of a main stroke is called a serif. Over the years, the serif has evolved quite a bit.

So, now it's up to you. Create some new shoes for your feet to wear!

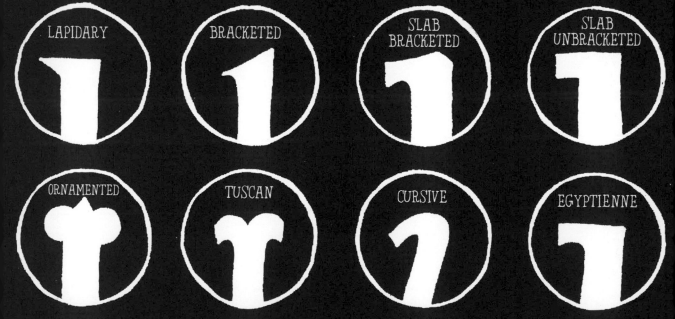

LAPIDARY · BRACKETED · SLAB BRACKETED · SLAB UNBRACKETED

ORNAMENTED · TUSCAN · CURSIVE · EGYPTIENNE

Serifs commonly show up in sans serif alphabets. Can you guess which letters?

I and J

SANS SERIF

If the word 'sans' means without and we just learned all about serifs, I'm guessing that you could show me what sans serif type looks like.

Show me here.

That's right, type without feet. Sans serif type is admired for its neatness, modernity and minimalism. While sans serifs work beautifully on their own, it's also a great style to balance out a more ornate piece.

Choose a quote by a modern-day figure you admire. It could be an artist, a musician, a scientist, anyone. Use sans serif type in your piece. Does the type capture this individual well?

Script Lettering

Eat Diamonds FOR Breakfast & SHINE all day

Go with the flow

Letterers GONNA Letter

Fancy from Head to Toe

You're The Realest

Adventures in Formality

Formal

Letter a formal announcement telling the world how awesome you are.

Casual

Letter that same announcement casually.

Stay Classy

Keep it Casual

Blackletter

From medieval texts to academic diplomas to beverage labels to news headlines and even biker tattoos, blackletter type sure gets around. Nonetheless, it's not completely versatile, so be sure to keep the tone of your piece in mind.

Used mostly by the Germans, accused of being a barbaric script and rumoured to be the official script of Olde English, blackletter type has quite the history. While blackletter has many monikers, the two nicknames that say the most about its style are fraktur and broken type. Both nicknames essentially have the same meaning in that blackletter is formed by fractured, broken lines that break apart to make up the lines that form the letters. Unlike a bone fracture that can break in a random place, blackletter's lines break strategically and sharply at angles that mimic Gothic architecture.

Use this triangular grid to help you draw blackletter type.

ANTIQUE

Printing has changed so much over the ages that calling the old, beautiful, rare type that rolls out from a letterpress 'antique' seems appropriate. Antique type consists of bold, thick, chunky slab serifs and has also included some thoughtfully ornamented serifs. Although old-timey and Western vibes radiate from its appearance, antique type has become popular again and offers great contrast for lettering.

YEE HAW!

HOWDY PARTNER

DON'T SQUAT WITH YOUR SPURS ON

KICK OFF YOUR BOOTS & STAY A WHILE

HORSIN' AROUND

Pick a quote from your favourite children's story to hand-letter here.

Bonus points if it's set in the Wild West!

ORNATE

Ornate lettering is the decorated Christmas tree of lettering styles. Just like decorating a tree, take your stripped-down lettering and create ornamentation by adding patterns, swirly swashes or elaborate embellishments on and around the letters. Remember, ornate lettering is a novelty. Too many embellished features can draw attention away from the type and the message, so it's best to use them sparingly so that your design maintains clarity and balance.

How Charming

VOILA!

SO DARLING

ENCHANT

HOPEFUL ROMANTIC

What are some novelties in your life? Hand-letter them here with some ornamented lettering.

When I began lettering, I focused so much on the letters themselves that I forgot that there are many extra elements that can be added around the text itself. Here are some examples so that you won't make the same mistake.

OUTLINE & INLINE

filigree

TYPOGRAPHICAL FLOURISH

THE Drop Shadow

PATTERN

Practise hand-lettering the word 'extra' using your newfound extra elements.

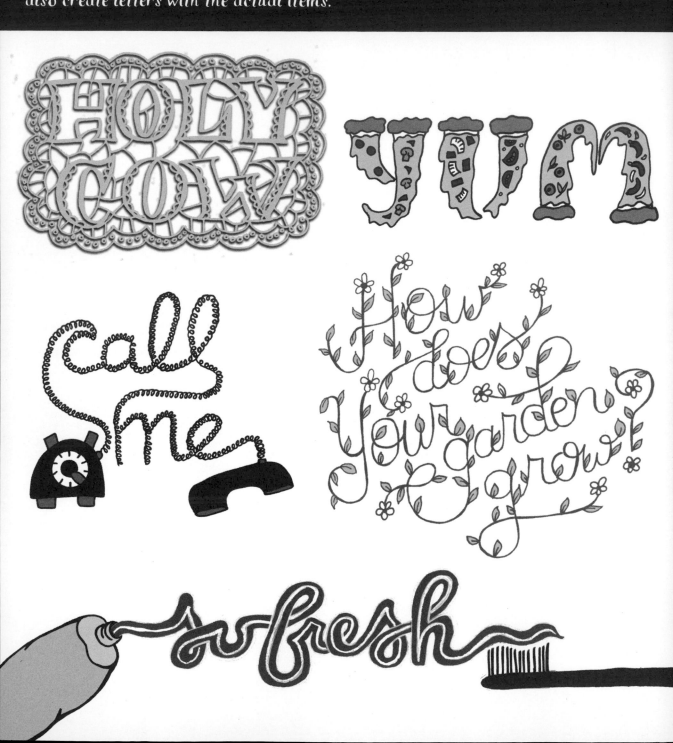

What's the first thing that comes to mind when you hear the words 'art', 'travel', 'snacks', and 'technology'? Hand-letter these words here using representational lettering.

FREESTYLE

Ranging from highly decorative display typefaces to textured, grungy type, freestyle is not concerned with readability. If legibility is not an issue, go freestyle!

BUBBLY

FLOWY

dotty

SLIMY

SCRIBBLY

STENCIL-Y

LINEY

GRUNGY

ORNAMENT-Y

Note: Use sparingly, unless you want to induce eyestrain in your readers.

Fill this page with the word 'free' using different types of freestyle lettering.

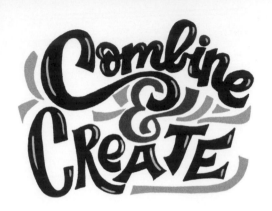

Now that we've explored the lettering styles, try your hand at the lettering process, from start to finish. Be inspired, come up with an idea for something to hand-letter, sketch it out, play and then ink your piece here.

What did your process really look like? Draw it below.

What part of your process would you like to change?

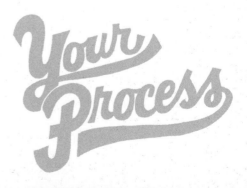

CREATIVE CONFIDENCE

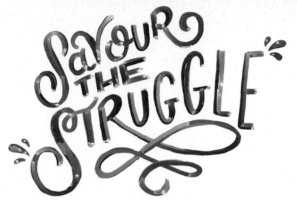

Do you want your hand-lettering to become faster? Stronger? Easier? Do you also want rainbows to jump out from everything you create? Yeah, I know how you feel. Whenever I learn something new, I feel just like I did when I was little—always wanting to feel bigger and better. I'd always forget about where I was in the present since I'd focus on what's next. But now I know better!

And now I'm telling you to stop all that worrying about the future. Cherish these days. They're tricky, time-consuming, frustrating, but honey, they build character in you and your letters (get it, characters?). You will have that 'aha! moment' soon enough, just don't expect it overnight.

Letter the phrase 'it gets better'. When finished, write your struggles around it. When you're no longer struggling with a particular struggle, cross it out.

FRUSTRATION

DOODLE YOUR FRUSTRATIONS OUT!

Over the next week, come to this page and spend five minutes lettering the quote 'practice makes perfect' each day.
Watch how you improve!

Day 1

Day 2

Day 3

Day 4

Day 5

Day 6

Day 7

Back in art school, I took a portrait painting class. At the beginning of the class, our teacher noticed all of us spending too much time on the little details, leaving many of us with unfinished masterpieces. To break away from focusing on the itty-bitty details, our professor gave us big brushes and asked us to paint quick, time-limited mini sketches. The sketches were really fast—some were only 30 seconds! Although my sketches did not represent the full likeness, it taught me to think of the big picture rather than fussing over the small details.

Try timing yourself lettering this phrase by Sigmund Freud, 'Time spent with cats is never wasted,' or letter a phrase of your choice. Focus on the overall layout and lettering placement. If you find yourself with leftover time, allow yourself to think about detail and stylizing your type.

10 Minutes	5 Minutes

3 Minutes	1 Minute

ERASE THE ERASER

Let's break the eraser habit for a minute. Cover these pages in graphite or another erasable medium. Then, use your eraser to hand-letter a message to your inner perfectionist.

Note the awesome texture!

HAPPY MISTAKES

Take a piece from your hand-lettering
graveyard. If you think you messed up,
think again. Keep working on it and
turn your mistakes into happy mistakes.

Think of something you've done or said that is memorable enough to be preserved in a history book. Letter it here—but ditch the eraser! Make your mark on the world with a permanent material. Start out with thin lines and build on your letters to mould your type.

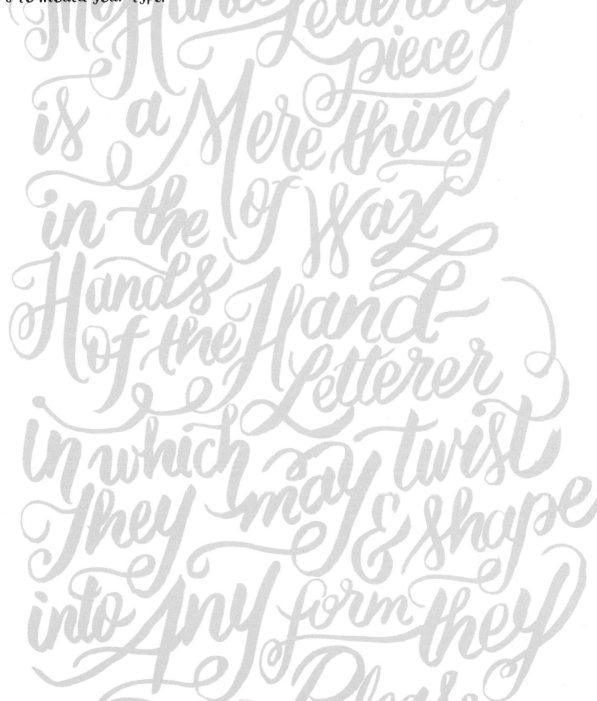

The Hand Lettering piece is a Mere thing of Wax in the Hands of the Hand-Letterer in which They may twist & shape into Any form they Please

Once you get into the habit of sketching, it helps build confidence to use permanent materials without the pencil's help.

Too often, I get caught up in the desire to perfect everything. Then I remember that it's called hand-lettering for a reason. I know how cliché this is going to sound, but let's get real. The quirks from your hand help build your lettering's unique character and set your work apart.

Before you think about redoing something because a line wasn't straight, the corner wasn't round enough or something wasn't smooth enough—stop! I challenge you to appreciate lettering's little quirks.

What is the quirkiest thing about you? Letter it here. If you feel the need to erase, think again. Make the quirk work!

Imperfections are Genuine. Embrace them

Allison Tylek

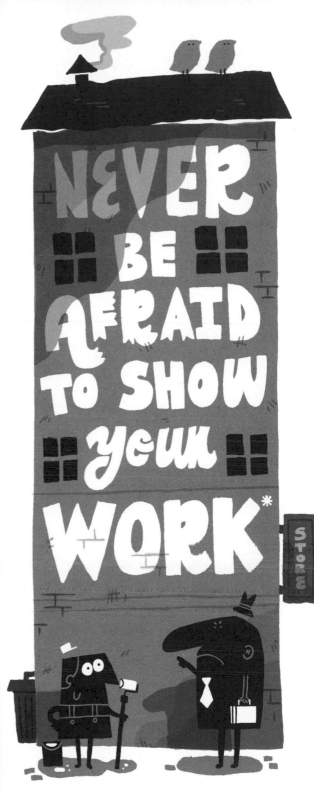

NEVER BE AFRAID TO SHOW YOUR WORK*

STORE

*NO MATTER WHAT PEOPLE THINK.

Nick Stokes

LOOSEN UP WITH A NEW MATERIAL

While pencil and ink have their place, don't forget the amazing array of art supplies out there. Their variety opens up new worlds for your lettering.

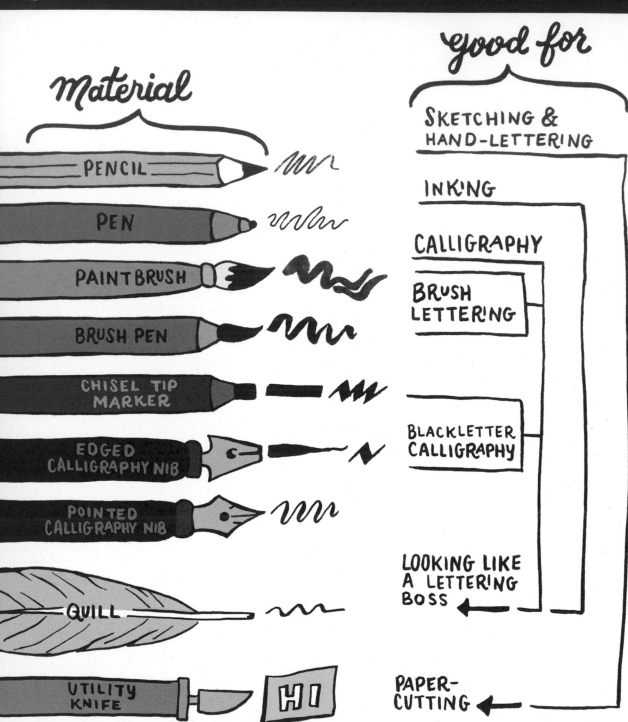

Material

- PENCIL
- PEN
- PAINTBRUSH
- BRUSH PEN
- CHISEL TIP MARKER
- EDGED CALLIGRAPHY NIB
- POINTED CALLIGRAPHY NIB
- QUILL
- UTILITY KNIFE

good for

- SKETCHING & HAND-LETTERING
- INKING
- CALLIGRAPHY
- BRUSH LETTERING
- BLACKLETTER CALLIGRAPHY
- LOOKING LIKE A LETTERING BOSS
- PAPER-CUTTING

HI

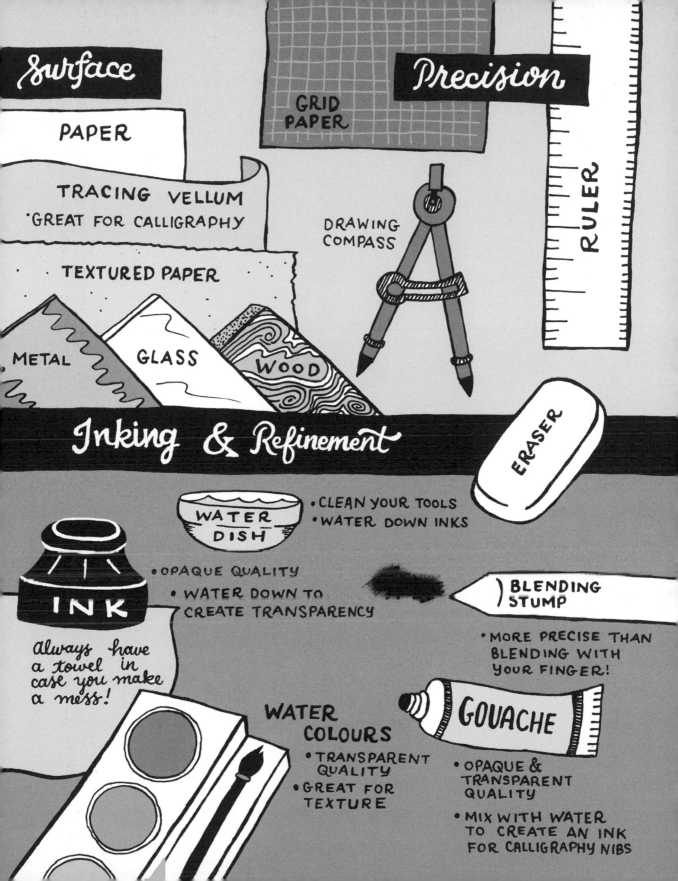

RE-IGNITING *your* CREATIVE SPARK

After working on a piece for a while, it's easy to lose your enthusiasm, especially when things aren't going as smoothly as you had hoped.

Here are my favourite ways to rekindle the flame of excitement.

SLEEP when you're TIRED {NOT DEAD}

Put your piece away. Sleep on the idea and work on your piece again in the morning. In the morning, letter your dream here.

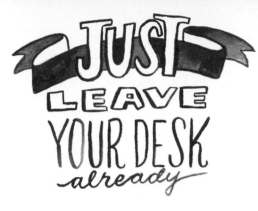

Change your setting or environment, especially if you've been working in the same location for ten hours or more. If you'd like to work indoors, consider a café, museum or library. If you'd like to work outside, consider a garden, park, back-yard, porch or swing.

Create a hand-lettering landscape for your ideal destination. Hand-letter the things you envision in this perfect place. For example, if there's a house, write the word 'house' in the shape.

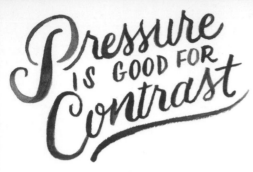

My absolute favourite way to regain enthusiasm for a piece is to switch up my art supplies. Sometimes using a new material can jump-start inspiration like nothing else.

Grab all the art supplies you own. Test the line weight of each material. Cover this page in different lines! Don't be afraid to apply heavy pressure to your writing utensil.

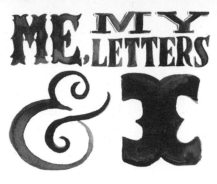

When you're caught up in a project, sometimes you need to take a step back and remember to have fun with your lettering. When I need a pick-me-up, I like to think about what I love most about lettering and develop a personal project for myself.

1) What lettering skills are you best at?
2) What is something new that you want to learn?
3) Think of ways to combine your two answers above. Letter yourself a thought cloud here.

4) Circle your three favourite ideas from above.
5) Pick one idea to pursue.
6) How will you make this? Will it be a series? What kind of materials will you use?
7) Give yourself a deadline to finish this project. Deadline: _____

Is your enthusiasm back yet? If yes, woo-hoo! If no, repeat steps 1-7.

See this alphabet? I chose 27 of my friends and sent each of them a message asking them to hand-letter a specific letter in order to create a whole alphabet. Other than creating personal projects, I also like to collaborate with my friends. Involving others is a fun way to nurture friendships, motivate each other, and create something awesome together.

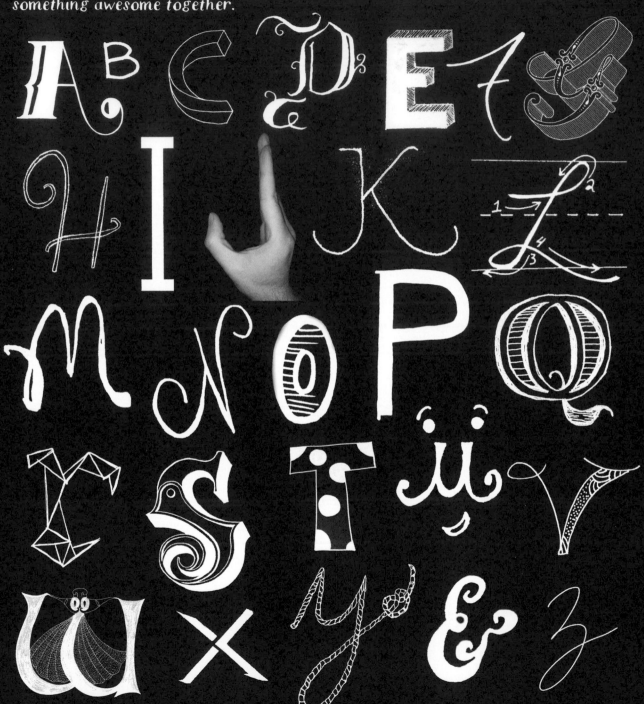

Hand-letter this page with a friend. Pass the page back and forth, adding to each other's input. Need an idea to start lettering your piece? Think about one of your shared interests and letter that word. See where the piece takes you!

Below are different parts of speech that will create a one-sentence story. Hand-letter the first item on the list, fold and then pass it to the next person. When you're finished, you'll have a fun lettering piece and mini-story.

(The) adjective

noun

verb

adverb

(to the) noun

(in order to) verb

(with the) adjective

noun.

Friends love to hear about your passions—it's almost like unwrapping a present! Share your newfound gift and hand-letter a postcard to a friend. Tell him or her about your hand-lettering journey.

OH HONEY, LOOK HOW MUCH YOU'VE GROWN

You've made it to this point! Now you're ready to dive even further into your curiosities, break some rules, experiment and explore further into the world of lettering. Woo-hoo!

Take a few pieces from your lettering graveyard and paste them here (as if it were a timeline) and then look at your progress.

EXPLORATION

Rehandwrite History

Examine some historical documents. Were they written in cursive? Is there calligraphy? Was there a custom, hand-lettered monogram? Now it's your turn. Re-create an old document with hand-lettering.

Signature STYLE

Unfortunately, so many signatures look like a chicken scratch these days. Why have a scribble represent yourself when you could have some swagger with signing your name?

Fill this page up with swanky signatures.

Pro tip: Remember to use your ligatures, or type united by a common characteristic, when possible!

HANDWRITING SAMPLES

Using your cursive handwriting, write your uppercase and lowercase alphabet below.

In cursive, write this pangram: 'The quick brown fox jumps over the lazy dog.'

Fun fact: A pangram is a sentence that uses all 26 letters of the alphabet.

WHAT DOES YOUR HANDWRITING EXPRESS?

Graphology is the study of handwriting. By studying cursive writing samples, graphologists say the way we craft our letters and words can indicate as many as 5,000 different personality traits. What does your handwriting say about you?

Using your handwriting samples on the previous page, find out what your handwriting expresses with this nifty guide.

CROSSING YOUR T'S

TOP — Top: optimistic, has great ambitions

LONG — Long cross: determined, has a hard time letting things go

SHORT — Short cross: careless, lacks ambition

MIDDLE — In the middle: confident, comfortable in own skin

SIZE

large — Large: outgoing, big personality

small — Small: introspective, shy

average — Average: well adjusted

SLANTING

right — To the right: open, sociable

left — To the left: reserved (if you're right-handed, it shows a rebellious side)

straight — Straight: logical, practical

TITTLES

CIRCLE — Circle: childish, visionary

SLASH — Slash: critical, impatient

TO THE LEFT — To the left: dilly-dallier, tends to procrastinate

TO THE RIGHT — To the right: organized, pays attention to details

LOOPS

CLOSED 'E' — Closed e: sceptical

OPEN 'E' — Open e: open-minded

CLOSED 'L' — Closed l: tense

OPEN 'L' — Open l: relaxed

SHAPING

round — Round: artistic, creative

pointed — Pointed: aggressive, curious

Although handwriting is not the same as hand-lettering, it's fun to know a little bit more about ourselves and the way we shape our letters.

Cursive is COOL

While many classrooms near and far are not teaching children their loops and swoops anymore, there are plenty of reasons to stand behind the cause to keep cursive alive.

History

Cursive is expressive in a variety of ways, whether we realize it or not. Studies have also shown that people are able to compose and express ideas faster when writing by hand than when using a keyboard.

Expression

Invented in 1500, English cursive script has evolved across 13 different writing styles and has been seen in documents ranging from supremely important to simple correspondence between friends and family.

Brain Stimulation

There's great value in cursive when it comes to learning. Sparking synchronicity between the left and right sides of the brain, the movement of writing has been proved to build pathways, improve mental effectiveness and help the brain develop in more productive ways.

Motor Skill Development

Fine motor skill development, or the coordination of small muscle movements, is linked with the process of cognition. As children develop, the sense of touch is very important when learning and processing information. There's a great benefit to the tangible act of tracing a letter on a page. Handwriting activates larger brain regions involved in thinking, language fluency and memory.

PRETTY COOL, right?

Fight for Your Writes

Do you know anyone who loves cursive? Ask them to share their signatures below. Do you know anyone who doesn't like cursive or writing by hand? Tell them about the benefits of cursive, and then ask if their opinion has changed. If so, ask them to sign below too. #bringbackcursive

Did you note any interesting ways people signed their name above? Use something you found interesting and incorporate it into your signature below.

After learning the benefits of cursive,
DO YOU THINK IT SHOULD BE KEPT ALIVE?

[] Yes! [] No

If you voted yes, write to your school board or legislator here in your best cursive handwriting and tell them why cursive should stay.

Dear _____,
I think cursive should stay in school because...

Share your thoughts with #handletteringforeveryone

ZERO IN ON QUIRKY DETAILS THAT MAKE YOUR Handwriting UNIQUE & EXAGGERATE THEM

Annie Trincot

Create WORK you ENJOY AND Help others

Chris Ballasiotes

EXPERIMENT {or else}

True love comes when you least expect it. I discovered my love for calligraphy when I borrowed a pen from my dad, thought it was magical and decided that I needed to have a means for me to keep learning and practising my newfound love. So I traded my phone's keyboard for the nib and invented modern-day snail mail. I text-messaged calligraphy messages for a week.

Time for some of your own modern-day snail mail! Send a hand-lettered text message. Write your note, snap a photo on your phone and click send. How long can you keep it up? Try for at least one day!

THE Pen is mightier THan THE KEY

Time for some more digital detox.
Replace something else you type (like a status update on social media, email window, book report, etc.) with some hand-lettering. Watch your friends' reactions.

Did some funny responses roll in?

CHOOSE YOUR FAVOURITE RESPONSE & LETTER IT HERE

To surprise your friend a bit more, send your hand-lettering along via snail mail.

the flourish

Flourishes are the added decoration to a letter or phrase. They can be large and dramatic or miniscule and subtle. Used in both print and cursive, flourishes help maintain overall balance within a word or phrase. They add an unexpected twist and can give your lettering some pizzazz.

Cover this page in flourishes.

Pen Your Pal

When was the last time you received a letter? Can't remember? That's what I thought! Pick the tenth person in your contact list and hand-letter that lucky person a note catching up on life since the last time you got together.

enveloped in style

Envelopes are actually one of my favourite things to letter. They're like wrapping paper, offering a hint of what's inside. I like to make my envelopes fun—and test what makes it through the mail.

Things you'll need: pencil, a large, flat eraser, ink or an inkpad, utility knife

1) Pick a letter and sketch here.

2) Now draw *the letter backwards*.

3) Take your eraser out and sketch your letter onto it backwards. Grab a piece of tracing paper and go over your piece with soft lead or chalk. When finished, press tracing paper onto the eraser to transfer the outline.

4) Carve out the negative areas around the letter.

5) Ink the letter.

6) Press the letter onto this page.

Use your plate as a blank canvas and your food to make some delicious lettering. If you can't sneak in a masterpiece at the dinner table, draw some letters using food instead.

Share your masterpiece with #handletteringforeveryone

LISTEN
WHEN
YOU ARE
TALKING
TO YORSLF

Rob Lewis

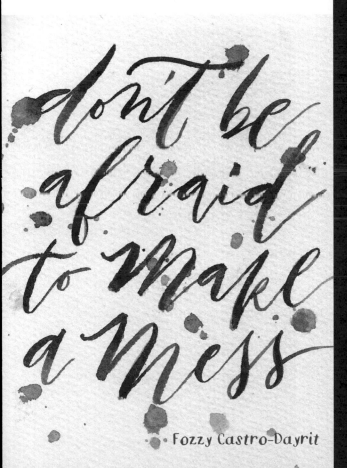

don't be
afraid
to make
a mess

• Fozzy Castro-Dayrit

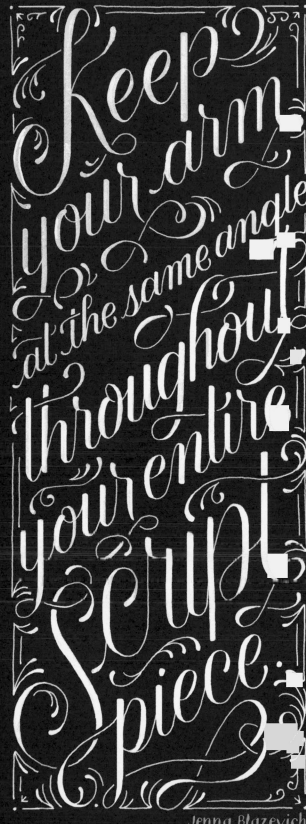

Keep your arm at the same angle throughout your entire script piece.

Jenna Blazevich

TEXTURE

LIBRARY

Fill in the boxes with different textures. Refer to this page when you want to add different textures to your hand-lettering.

PATTERN

— APPLICATION —

Outline your favourite sans serif font lightly with pencil. Instead of filling the inside of your type with a colour, fill in the letters with a pattern. Erase the type's outlines.

Is there something exciting happening in a
friend's life? Take some chalk and letter
some good vibes using that friend's
drive/pavement/porch as your canvas.
Sketch out your message here.
Remember to take a photo!

What's your most far-fetched dream?
Use glue to hand-letter that dream.
Sprinkle glitter, small beads or cotton
balls onto your type while the glue is drying.

1) Draw the outline of your favourite animal.

2) Letter the name of the animal within the outlined shape.

3) Colour your lettering with one colour.

4) Fill in the shape with another colour.

BECOME THE SHAPE

1) Keep the shape of that same animal fresh in your mind.

2) Shape your letters to form the outline of the animal.

3) Fill in the type with one colour and leave the surrounding areas blank.

The shape of your overall type should look like the animal!

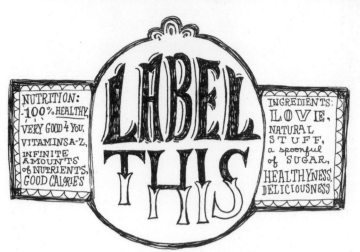

NUTRITION:
-100% HEALTHY,
VERY GOOD 4 YOU,
VITAMINS A-Z,
INFINITE
AMOUNTS
of NUTRIENTS,
GOOD CALORIE'S

INGREDIENTS:
LOVE,
NATURAL
STUFF,
a spoonful
of SUGAR,
HEALTHYNESS,
DELICIOUSNESS

Take the label off a package of food or
another type of product you use often.
Think about how you would design it
differently. Re-create the label here.
When you're finished, cut out the label
and paste it to the original container.
See if anyone notices the change.

Whatever you do
do it with
some life

Timothy Goodman

YOU
CAN
ONLY
Get
Better

Josh
LaFayette

Cover this page with dots. Connect the dots to form letters.

Get your stipple on like Seurat by forming letters out of small dots.

I know, I know, that took a lot of time. Imagine how long a pointillist painting must have taken!

& THE AMPERSAND

Formed from the phrase 'per se' and 'and', the ampersand is loved by many designers and hand-letterers alike. It is adored so much that there are a variety of ways to create the beautiful symbol. Cover this page with ampersands.

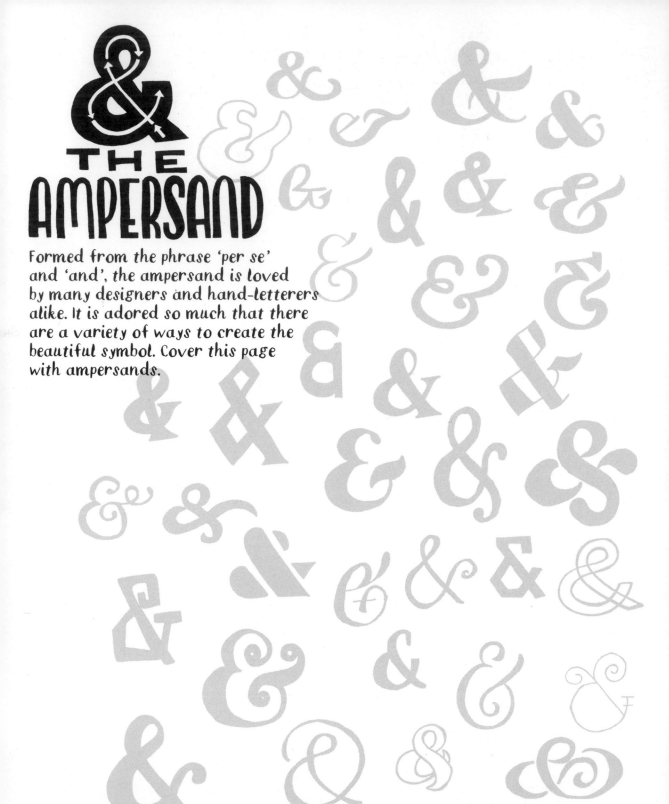

Pro tip: Whenever you have the word 'and' in a quote or phrase, think about substituting an ampersand to jazz up your design.

Do you have a friend who borrows things and doesn't give them back? Create a ransom note to demand the release of that special something from your friend's captivity.

Cut letters out of books, flyers, magazines, newspapers and other printed matter and construct your note here.

Rip out your favourite pages from a magazine. They could be of anything (beach scenes, type from an article, flowers, blocks of colour). Create outlines of type on top of the pages you've selected, and then cut them out and paste them onto this page. Fill the page with cut-out letters.

Sketch an outline of type. Take magazine pages of various colours and styles and cut them into thin strips. Fill in your type with the strips and paste them within the outlines.

SIGN
Painting

Until the 1980s, many outdoor signs were actually created by hand. After years of extensive training, sign painters gain a great sense of precision and skill when manipulating their brushes, creating works of beauty and clarity.

Using the last location you visited as your lettering subject, create a sign of said location on this wall.

Want to really go pro? Use a brush, paint and a clean surface (wood, sheet metal, glass, masonite board) to hand-letter like a true sign painter.

Brush Lettering

Brush lettering is all about confidence and consistency. Pay attention to the pressure you use throughout your strokes. Twist the brush lightly on curves, and lighten up on the pressure when you approach the end of a stroke. Grab a brush and practise some brush lettering here.

more Pressure ON YOUR Downstrokes

FIND the write PRESSURE as you write

Lighten up ON YOUR Upstrokes

Tip: The more pressure you apply, the fatter your line will be. The less pressure, the thinner your line will be.

FIELD TRIP

You can find brush lettering and sign painting in many grocery stores. It's worth taking a field trip to check it out. For practice, make some signs below with your favourite produce on sale.

CLAIM *Inspiration* WHEREVER YOU CAN FIND IT.

Frances MacLeod

USE THUMBNAILS

START SMALL

PLAN IT OUT! Gabriella Thompson

Beauty › Form › Letter › Context

John Passafiume

Stencils are great for when you want to create multiples of a particular design, or to assure that your design stays in place while applying it to something important (for example, printing a T-shirt).

Create a nickname for yourself and sketch it below. When sketching, plan wisely; remember that bowls and eyes will be punched out fully if you cut letters true to shape. Then, take a durable surface like cardboard or a plastic sheet and sketch your pattern, and cut your letters out of the surface with scissors or a utility knife. When finished, take some ink or paint and colour through the cut-outs to reveal your nickname.

Share your stencil with #handletteringforeveryone

Intricate paper stencilling is known as the art of papercutting. Similar to stencilling, papercutting takes subtractive lettering and design to another level. Since paper is thinner, it is easier to cut through and you can create a more detailed piece.

I always feel risky whenever papercutting. Once you remove a bit of paper from your piece, you cannot simply paste it back onto the page. Below, letter a risk you'd like to take and try your hand at papercutting!

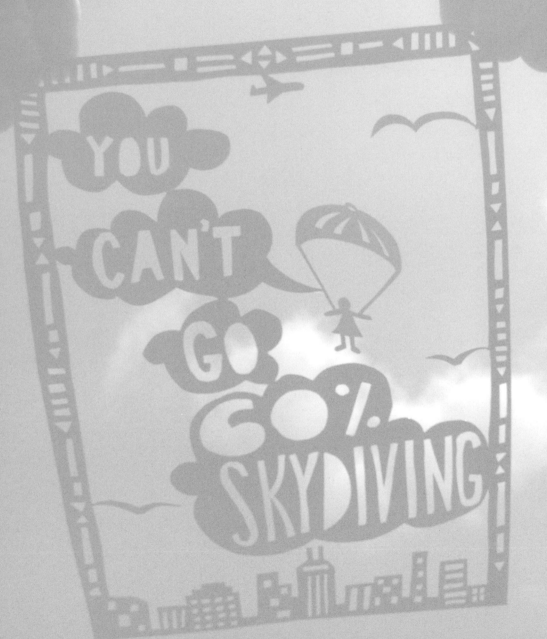

Get Loose!

Explore / Experiment / Play with different media to discover what works for you.

Karen Kurycki

You Don't Get Better at Life by Scrolling

Will Bryant

What's something that makes you feel extra good? Hand-letter it here. Place dots along the connecting points and curves of your letters. After dotting up your word, erase the lines in between. Using a needle and thread, sew the dots together to form the word on this page.

Feeling ambitious? Keep sewing back and forth to form some contrast among your strokes.

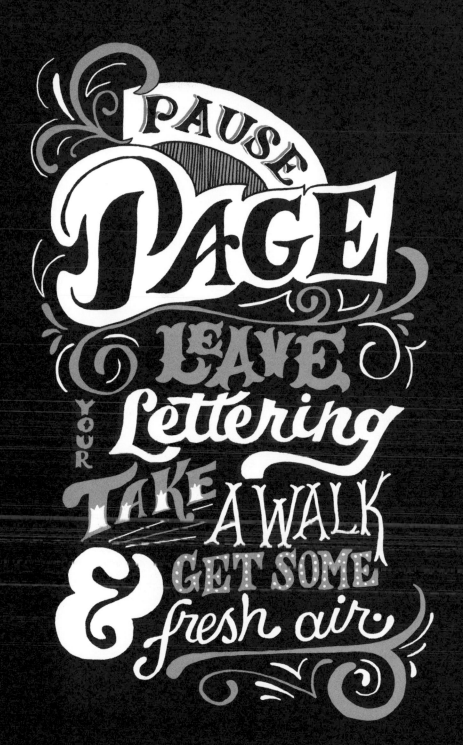

LICENCE 2 LETTER

Notice how all licence plate type looks the same? Letter some licence plates below to illustrate a few of your favourite places!

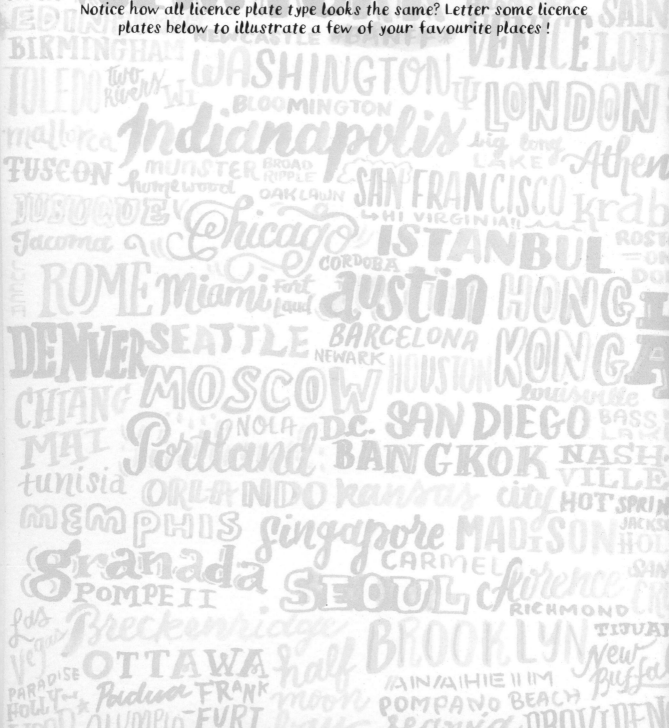

When you're finished, cut out each of the squares, paste the pages together at the left-hand edge, and flip through the pages of your flip book to see the evolution of this awesome letter.

IDEAS

MAKE GREAT things

Sucking at something is the first step at being sorta good at something

Janie Javier

Slow Down

Bob Ewing

to infinity

Cover this page with your favourite letter. Make sure that no two versions look the same.

Cover this page with your <u>least</u> favourite letter. Again, make sure none of your letter designs repeat themselves!

and beyond

the great Outdoors

Take a walk outside. Pick up materials
from nature and use them to spell out
the name of the season. When you're
finished, sketch out what you made here
(or include a photo).

RAISE THE ROOF

Pick up some objects lying around your home. Make some type with them. When you're finished, sketch out what you made here (or include a photo).

EXPERIMENT

Jill De Haan

Moderation is for Quitters

Carolyn Sewell

I often see a face when I look at the front of a car and objects formed by clouds. On the same note, I see letters in everyday objects and in nature. Document the letters you see the next time you're out and about.

By now, you should know that lettering type is not limited to putting ink on paper. Now, let's switch it up and make type out of paper. Pick a number, count to that number in the alphabet. Cut this page into strips and bend, fold and roll your paper in order to form the letter you chose.

If you want to get fancy before folding, fill this page with letters or patterns to give your letter a texture.

DEFINED LETTERING

Grab a dictionary, close your eyes and choose a random page. Wherever your finger lands, hand-letter the chosen word and definition. If possible, combine lettering and illustration together.

Lightly sketch out the lyrics to
a song that makes you move and
shake. Did you make straight lines?
If so, replace them with squiggly,
wavy ones.

Letters HAVE A VOICE, Make them SING

Risa Rodil

Start with a BASIC line, then add weight

Kristin Drozdowski

Surprise someone special with a meal.
When you're ready to eat, pretend
you're in a restaurant and hand
your guest the hand-lettered menu:

Not So Cookie Cutter Type

Are you hungry after lettering that menu? (I hope you're not hangry!) Make some delicious cookies. After you finish mixing your ingredients, form your dough into letters to bake some letter shapes. When baked to perfection, flourish your type with icing or toppings and take a photo of your edible lettering!

Snap a picture of what you created and paste it here!

Client: You!
What are you about?
Do you have a slogan?
What are your best qualities?
How do you differ from everyone else?
What are your likes and dislikes?

You're your own client. Think about the
previous questions listed above in order
to create a hand-lettered logo for yourself.
Happy branding!

INITIALLY YOURS

Using your initials, create patterns in the boxes.

HERE'S my CARD

HI!

Everyone has a title, whether it's your profession or just a label you give yourself. Below, hand-letter some business cards for each of your titles or roles you play in life. When you're finished, cut them out and hand them to the next person you meet! When you're done, flip your card over. Don't the patterns look great too?

You WIN SOME YOU Learn SOME

Jay Roeder

Break the rules. Make your own Tools.

Hannah Boresow

DO you LIKE IT BECAUSE YOU'VE SEEN IT?

Jeff Rogers

You're Invited

Hand-letter an invitation to the party of the century.
Pick from the following before designing your invite
to guide design direction.

Who (is this party celebrating?): The Prime Minister, you!, a celebrity, an athlete, your mum
What (theme)?: robot, sports, mystery, costume, dress up, holiday
When?: 2000 BC, 1660s, 1920s, 2015, the future
Where?: outer space, beach, ancient Egypt, mountain top, medieval castle

Write your curses in cursive.

Let it
All
Out!

Aa Bb Cc Dd Ee
Ff Gg Hh Ii Jj
Kk Ll Mm Nn Oo
Pp Qq Rr Ss
Tt Uu Vv Ww
Xx Yy Zz

Who knew profanity could look so pretty?

Hand-letter your number here.

No prank calls, please!

TYPOGRAPHY BUSTERS

Find an advertisement that needs a hand-lettering makeover.
Cut out important elements from the ad and paste them here.
Revamp your ad by replacing the typography with hand-lettering.

Flip through some comic books. Notice that hand-lettering? There are lettering artists who meticulously letter those superhero storylines for our reading pleasure. After examining a few comic books, cover this page with onomatopoeias, or words that imitate sounds, of your own.

MAKE AN ALPHABET OUT OF (FILL IN THE BLANK).

Fill in the blank above. Letter an alphabet using elements from said item.

start
bas
start loose
start
over

Leo Zarosinski

Sasha Prood

WHAT'S YOUR ANGLE?

What are some of your strongest opinions? Hand-letter your beliefs here without any curves; use angles and straight lines.

Putting limits on your letters (like no curves) is an excellent way to break out of your drawing habits.

Not So (straight) ("edged")

Confession: I cannot draw a straight line. Using anything but straight lines, letter your confessions. Use bold or slight curves, leaning lines or squiggly lines to create your lettering. Whatever you do, do not use a ruler!

What's the one thing you would love to tell the world? Do you want to tell people to recycle more? To stop looking down at their phones all the time? To laugh a little more? Letter it in large, clear type.

Cut out a picture of yourself. Hand-letter some information about you and your life around the image you chose. Be sure to include your proudest moments (so far).

Monograms are motifs of two or more letters, often initials,
that are intricately woven together. Let's make some.

For yourself:

For you and your best friend:

For your pet:

For you and your celebrity crush:

Learn the Rules

Neil Tasker

THERE'S FREEDOM in the imperfect

Laura Stephen

Hand-letter a love letter here.

Send your letter when you're finished—by mail or carrier dove!

 CAPITALS

People always seem to think that type in all caps means that the type is shouting...

Prove that it could be true.
Make lettering that screams here.

Now, show me that it isn't necessarily always true. Make quiet all-caps here.

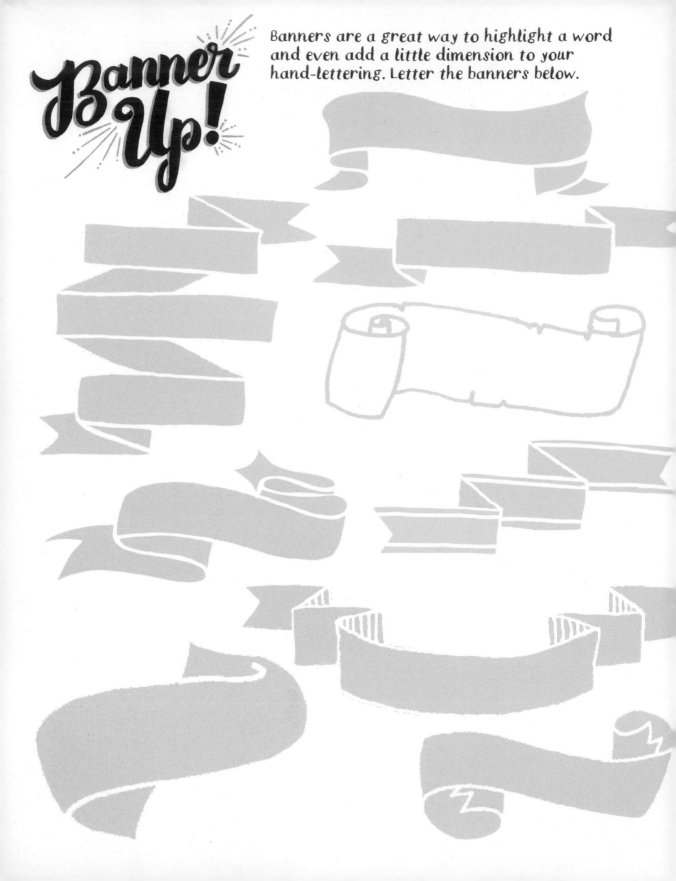

Banners are a great way to highlight a word and even add a little dimension to your hand-lettering. Letter the banners below.

Place letters inside all the triangles below. If you want to get fancy, cut out some of the triangles. Letter your word or phrase. Interweave a string between your letters to create a real-life bunting.

Buntings are great to decorate in real life or on the page within a hand-lettering piece.

History is filled with great stories of great things written on napkins. Big ideas have been sketched out, speeches have been written, phone numbers have been exchanged, and more. The next time you see a napkin, use it wisely. In the meantime, letter the napkin below.

Share your napkin lettering with #handletteringforeveryone

Have an idea for an invention?
Hand-letter an advertisement for your big idea here!

PAGE THIEF

Take a book off the shelf and open up to a random page. Rewrite the page using hand-lettering. Copy every word—no abridging allowed! When you're finished, slyly insert your page back into the book for a future reader to discover.

BLIND lettering

Absorb this quote. Close your eyes. Focus on your imagination.
Let your pencil run wild with lettering. No peeking!

YOU CAN'T depend on YOUR → eyes when your IMAGINATION IS OUT OF FOCUS

Letter your dream tattoo here.
Script lettering and blackletter
are popular styles for tattoos,
but with this tattoo, you can use
whatever styles your heart desires.

TATTOO YOU

Now that you're nearly a master hand-letterer, you're going to need a sign to let your friends know when your hand-lettering skills are open for business. Create a sign for your desk. On one side, hand-letter 'open', and on the other side, hand-letter 'closed'.

Never Judge A Book By Its Letters

You've just finished writing a book about your life.
What would the title be? Letter it here.

BOTTOMS UP

Show your barista how it's done by hand-lettering
your name on your cup with some style.

Meet the NEWEST GRAD ON THE BLOCK

LETTERING Master

THIS CERTIFIES THAT

has completed the course of study and therefore

_____ is prepared for

further advancement in hand-lettering.

When should I hand-letter?

Other than all the time,
use your hand-lettering
whenever you want to
customize something special.

To me, anything I write could be
taken as an opportunity to hand-letter.
What should I hand-letter now?

Now GO DO YOUR Hand-Lettering THING

Resources

Armstrong, Amanda. 'What Does Your Handwriting Say About You?', Real Simple, n.d. www.realsimple.com/work-life/life-strategies/handwriting-101.

'Blackletter', Wikipedia, n.d. http://en.wikipedia.org/wiki/Blackletter.

Bounds, Gwendolyn. 'How Handwriting Boosts the Brain', Wall Street Journal, October 5, 2010. http://online.wsj.com/article/SB10001424052748704631504575531932754922518.html.

Carpenter, Stephanie. 'Metal Type', 2015. Hamilton Wood Type & Printing Museum, Two Rivers, WI.

Carpenter, Stephanie. 'Slab Serifs', 2015. Hamilton Wood Type & Printing Museum, Two Rivers, WI.

Carpenter, Stephanie. 'Type Case', 2015. Hamilton Wood Type & Printing Museum, Two Rivers, WI.

Carroll, Lewis. Lewis Carroll's Alice in Wonderland, Somerville, MA: Templar, 2009.

'Cave Paintings', Art Chive, n.d. www.artchive.com/artchive/C/cave.html.

'Cursive', Wikipedia, n.d. http://en.wikipedia.org/wiki/Cursive.

'Family Classifications of Type', Families of Type. Spokane Falls Community College, n.d. http://graphicdesign.spokanefalls.edu/tutorials/process/type-basics/decorative.htm.

Geiger, Matthew J. 'How Cursive Writing Affects Brain Development', Kevin Trudeau Show, May 13, 2011. www.ktradionetwork.com/health/how-cursive-writing-affects-brain-development.

'Gothic Alphabet Step by Step', Calligraphy Skills, n.d. www.calligraphy-skills.com/gothic-alphabet.html.

'Handwriting Analysis Terms', Handwriting Insights, n.d. www.handwritinginsights.com/terms.html.

Harman James, Karin. 'Interview with Dr. Karin Harman James', Personal interview. September 2011.

'History of Typography: Humanist', I Love Typography, November 6, 2007. http://ilovetypography.com/2007/11v06/type-terminology-humanist-2.

'History of Typography: Old Style', I Love Typography, November 21, 2007. http://ilovetypography.com/2007/11/21/type-terminology-old-style.

'The History of Visual Communication', Citrinitas, n.d. www.citrinitas.com/history-of-viscom.

'Italics', Fonts.com, n.d. www.fonts.com/content/learning/fontology/level-1/typeanatomy/italics.

Kidd, Chip. Go: A Kidd's Guide to Graphic Design, New York: Workman, 2013.

'Movable Type', Wikipedia, n.d. http://en.wikipedia.org/wiki/Movable-type.

Nelson, Rand. 'What Is It About Cursive?', Peterson Handwriting, n.d. www.peterson-handwriting.com/Publications/PDF-versions/AdvantageCursiveRef.pdf.

Quigley, Elaine. 'How Graphologists and Handwriting Experts Analyse Handwriting', Business Balls, n.d. www.businessballs.com/graphologyhandwritinganalysis.htm.

Rob Roy Kelly. American Wood Type, The University of Texas at Austin, n.d. www.utexas.edu/cofa/rrk.

Sortino, David. 'Intelligence and the Lost Art of Cursive Writing', August 9, 2011. http://davidsortino.blogs.pressdemocrat.com/10036/intelligence-and-the-lost-art-of-cursive-writing.

'Type', Plain Language Network, n.d. www.plainlanguagenetwork.org/type/utbo211.htm.

Credits

page 41: Peter A. Carey, 'Star Power', 2015. (Instagram: peteracarey)

page 69: Robotix11, 'Green Grass in Spring', 2014.

page 126: Kristina Anderson, Alysha Balog, Nathan Bilancio, Hannah Boresow, Derek Cutting, Lindsay Davies, Desirée De Leon, Laura Engelhardt, Ross Frazier, Haley Hodgen, Lauren Hudak, Nathaniel Kenninger, Valerie Leek, Natalie Moya, Eileen Matthews, Melissa Pattee, Nicolas Perfetti, Julia Rickles, Aurelia Rohrbacker, Justin Schnarr, Joel Schneider, Katherine Taylor, Mayowa Tomori, Annie Trincot, Rita Troyer, Thomas Vanko, Lauren Wolfer. Collaborative Alphabet. Digital image.

page 164: Flashman, 'White Brick Wall Texture #3', 2008.

About the Author

Cristina Vanko is a hand-letterer, art director and Hoosier. Beginning with a childhood predilection for fine rouge lipstick and Hammer pants, her design roots are deep. Her personal touch imbues all her works, from campaigning for cursive handwriting to penning text messages in calligraphy via modern-day snail mail. She is a lover of life, laughter, pints of ice cream and pint-size dogs. This is her first book.

cristinavanko.com | @cristinavanko | #handletteringforeveryone

Portrait by Desirée De Leon

Acknowledgements

This book was made with the help of the following people: Eileen Matthews, Brittany Skwierczynski, Annie Trincot and Laura Stephen. Without you ladies, this book would not be where it is today. I cannot thank y'all enough!

Thank you to my friends and family whose endless encouragement has made this book possible. To my art-teacher dad, who introduced me to many artists at comic conventions from the time I started walking. To all my comic-con artist 'aunts' and 'uncles' who showed me that you truly can create a life doing what you love. A special thank you to my editor, Marian Lizzi, who believed in this book from the get-go.

Lastly, a shout-out to the calligraphy pen that started it all.
To all the inky adventures that were and await.

cw